TRANSFORM BIERS SCHOOL

For Walter and Molly

FOREWORD

You don't need to have any knowledge of art to introduce a child to a painting. You don't even need to know the name of the artist. All that is important is there in front of you in the picture, waiting to be discovered. Children love to look for details and will probably spot them before you do – the broken jug, the bird in the tree, the funny fish. You could talk about what the people are doing and what they're wearing, think about the time of year, the shapes and the colours and contrasts. Is it a quiet painting or a noisy one? Does it make you feel happy or sad? Is it old-fashioned or modern? Does it make you laugh? Could you copy it?

The children who helped me choose this small selection of paintings showed little interest in the artists, but they know the paintings inside out and will, I'm sure, remember them. I hope that the children sharing this book with you will enjoy the paintings as much as we have.

Lucy Micklethwait 1996

Cover picture: Ernst Thoms, *Train* (1926) Title page picture: Vincent Van Gogh, *The Langlois Drawbridge* (1888)

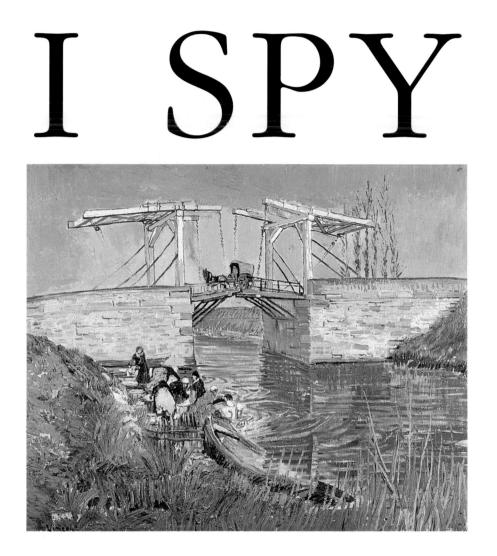

– Transport In Art –

Devised & selected by Lucy Micklethwait

Collins An Imprint of HarperCollinsPublishers

a car

Mel Ramos, Batmobile

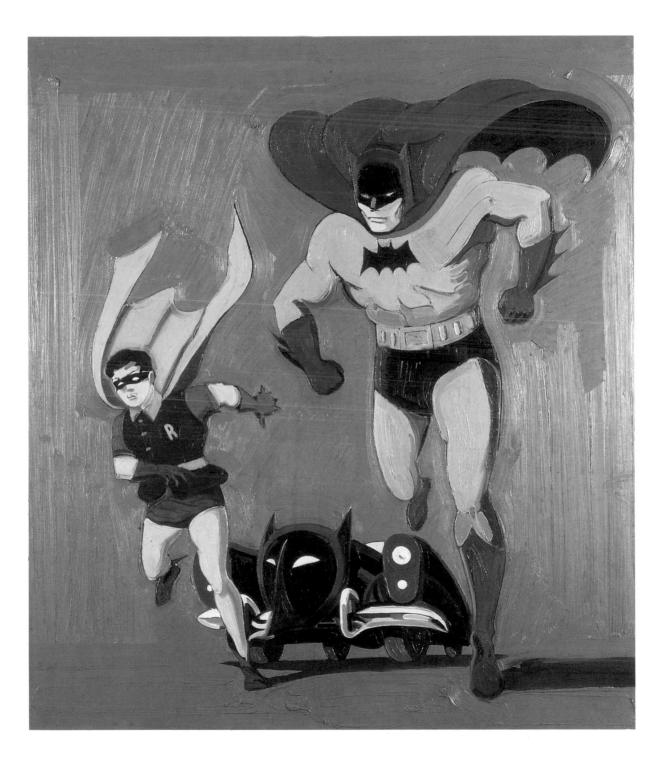

DIEDOM HIGH SCHOOL

I spy with my little eye a ship

Edward Burra, The Annunciation, or St. Anne, St. Agnes and St. John Zachary

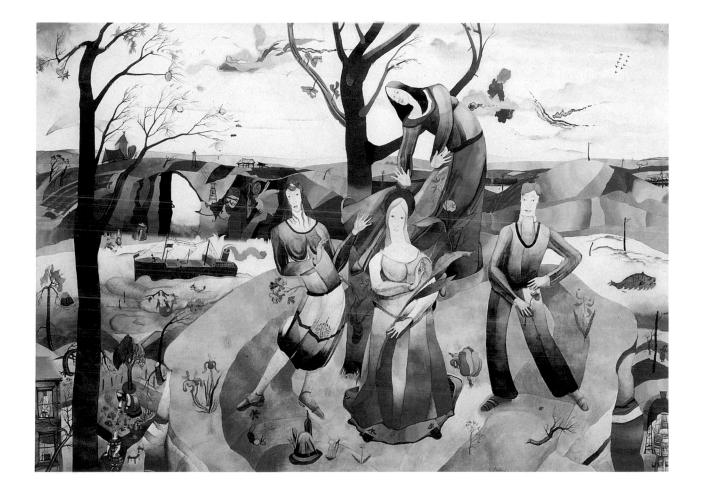

an aeroplane

Eduardo Paolozzi, Wittgenstein at the Cinema Admires Betty Grable

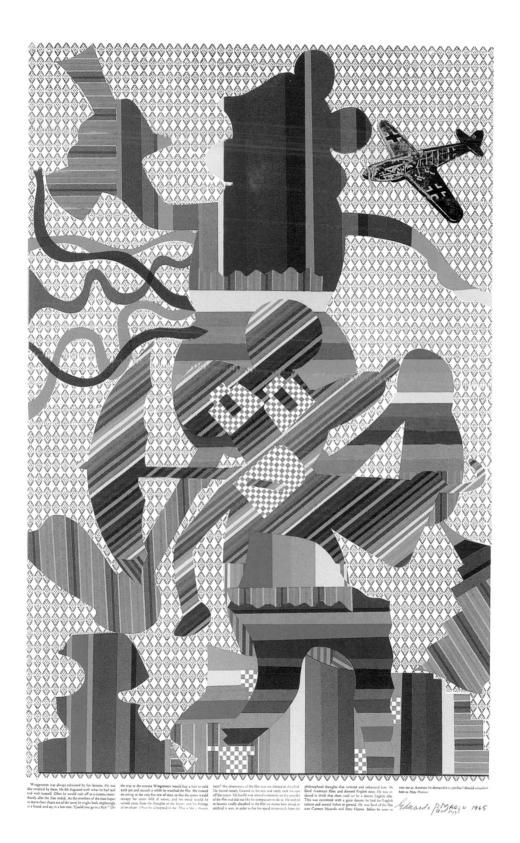

I spy with my little eye a horse

Stanley Spencer, Map Reading

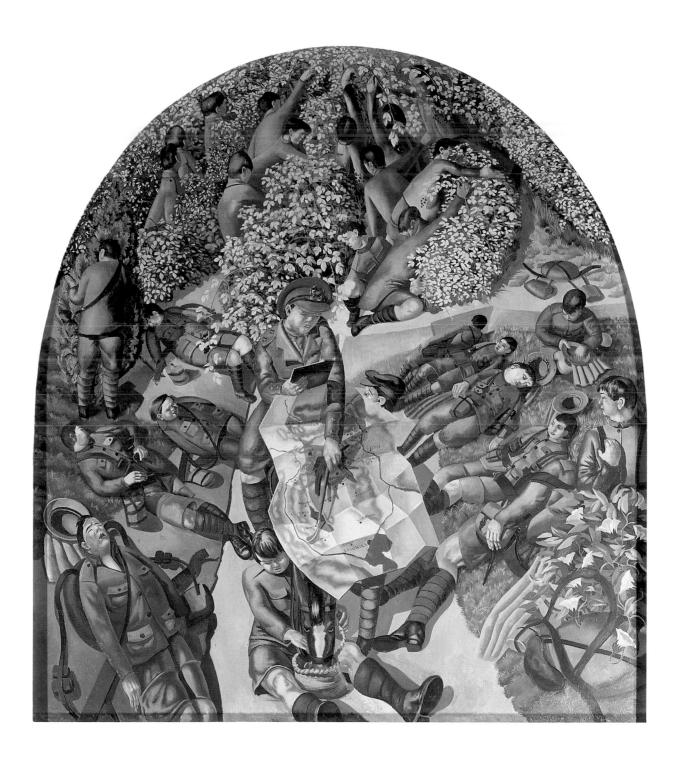

a rowing boat

Wassily Kandinsky, Birds

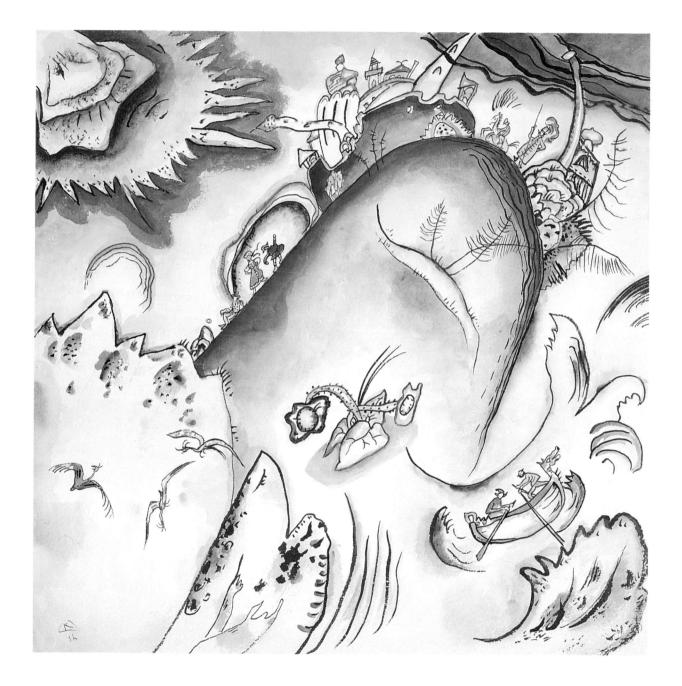

I spy with my little eye a sleigh

Hendrick Avercamp, A Winter Scene with Skaters near a Castle

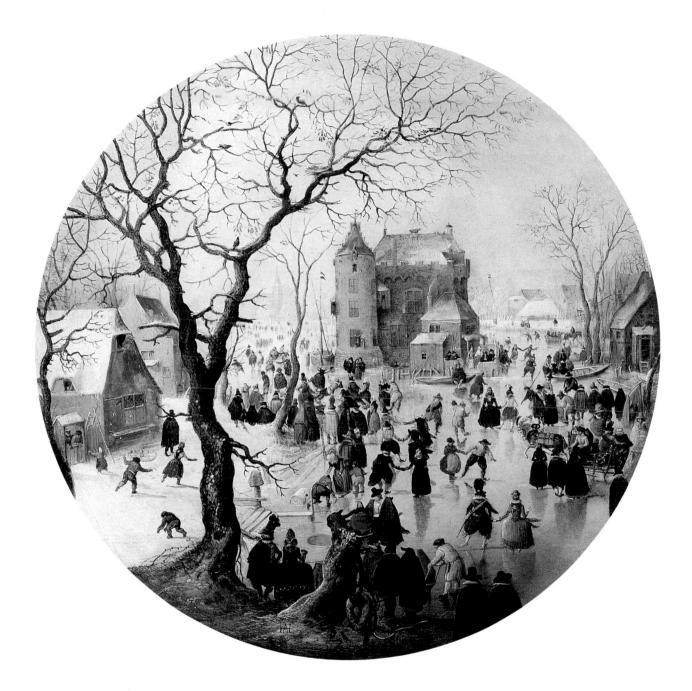

a wagon

Vincent Van Gogh, The Langlois Drawbridge

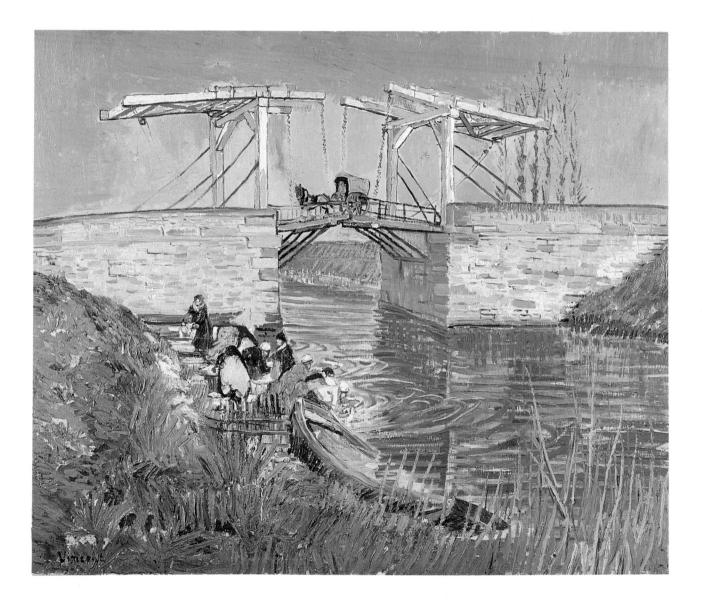

a camel

Salvador Dali, La Table Solaire

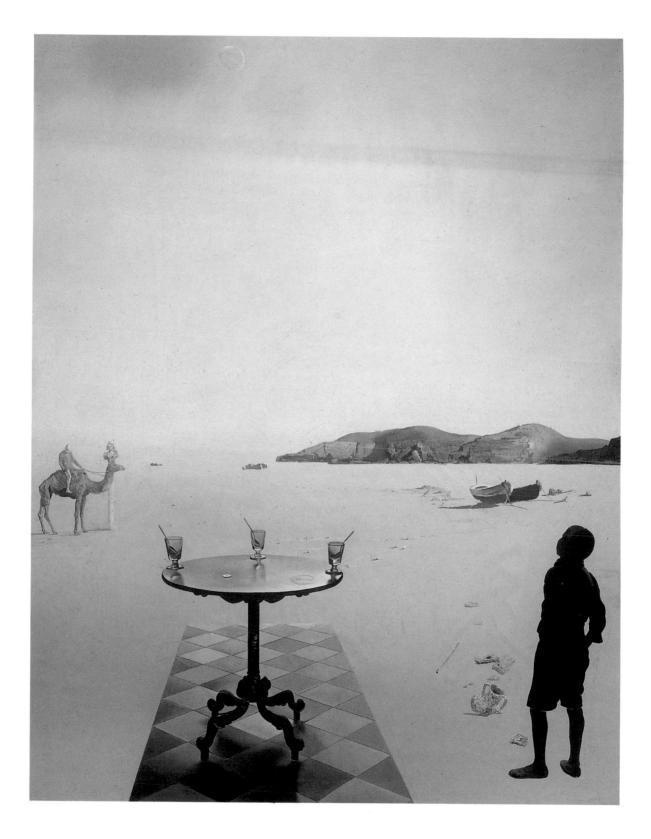

I spy with my little eye a bicycle

Wayne Thiebaud, Down Eighteenth Street (Corner Apartments)

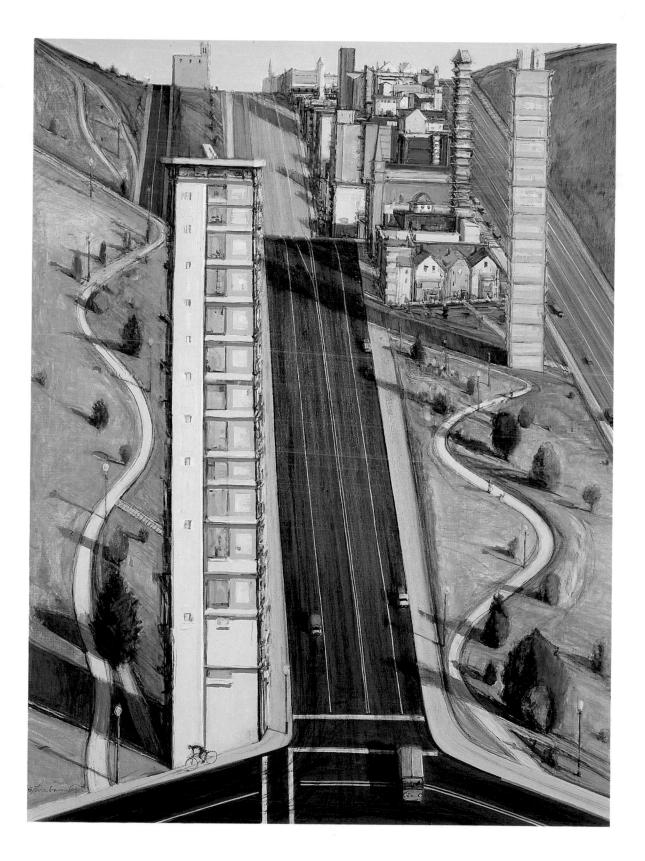

I spy with my little eye a train

Ernst Thoms, Train

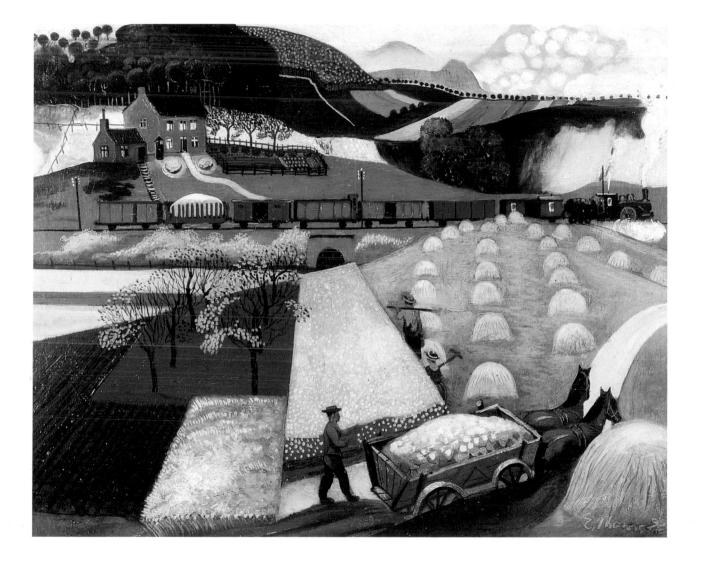

an elephant

Indian, The Siege of Ranthambore

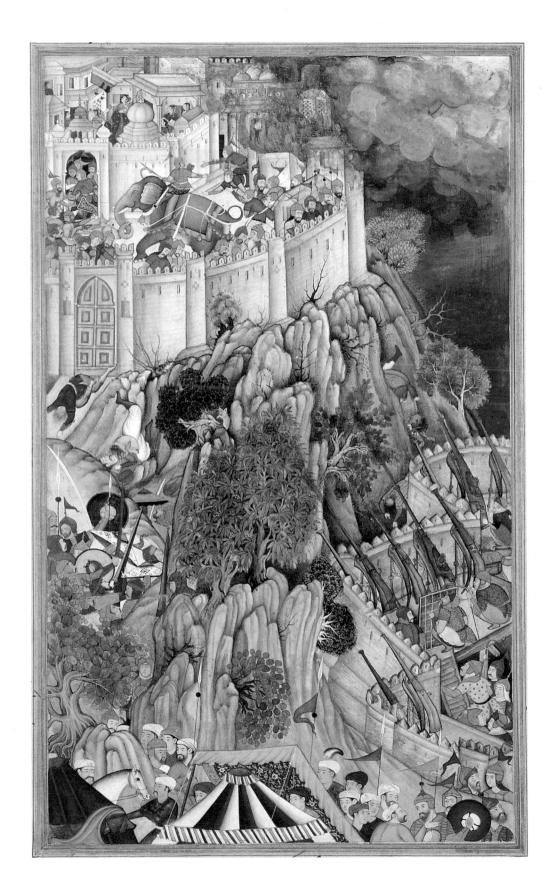

- I Spied With My Little Eye

Car

Mel Ramos (born 1935), *Batmobile* (1962) Museum Moderner Kunst, Vienna Bequest of the Austrian Ludwig Foundation

Ship

Edward Burra (1905-1976), *The Annunciation, or St. Anne, St. Agnes and St. John Zachary* (1923) Private Collection

Aeroplane

Eduardo Paolozzi (born 1924), *Wittgenstein at the Cinema Admires Betty Grable* (1965) from *As Is When* (1964-1965) The Tate Gallery, London

Horse

Stanley Spencer (1891-1959), *Map Reading* (1932) Sandham Memorial Chapel, Burghclere The National Trust

Rowing Boat

Wassily Kandinsky (1866-1944), *Birds* (1916) Centre Georges Pompidou, Paris

Sleigh

Hendrick Avercamp (1585-1634), *A Winter Scene with Skaters near a Castle* (about 1609) The National Gallery, London

Wagon Vincent Van Gogh (1853-1890), *The Langlois Drawbridge* (1888) Rijksmuseum Kröller-Müller, Otterlo

Camel

Salvador Dali (1904-1989), *La Table Solaire* (1936) Museum Boymans-van Beuningen, Rotterdam

Bicycle

Wayne Thiebaud (born 1920), Down Eighteenth Street (Corner Apartments), (1980)

Hirshhorn Museum and Sculpture Garden, Smithsonian Institution, Washington, D.C. Museum purchase with funds donated by Edward R. Downe, Jr., 1980

Train

Ernst Thoms (1896-1938), *Train* (1926) Kunstammlung der Stadtsparkasse, Hannover

Elephant

Indian, *The Siege of Ranthambore* from *The Akbarnama* (about 1590) The Victoria and Albert Muscum, London

Hot-air Balloon

Roger de la Fresnaye (1885-1925), *The Conquest of the Air* (1913) The Museum of Modern Art, New York

Mrs Simon Guggenheim Fund

Pram

Richard Eurich (1903-1992), *Gay Lane* (1952) Bradford Art Galleries and Museums

ACKNOWLEDGEMENTS

The author and publishers would like to thank the galleries, museums, private collectors and copyright holders who have given their permission to reproduce the pictures in this book.

Mel Ramos, *Batmobile*, © Mel Ramos/DACS, London/VAGA, New York 1996 Batman, Robin and the Batmobile are trademarked and copyrighted © DC Comics. Used with permission.

Edward Burra, *The Annunciation, or St. Anne, St. Agnes and St. John Zachary,* Photograph Courtesy of the Lefevre Gallery, London

Eduardo Paolozzi © Wittgenstein at the Cinema Admires Betty Grable

Stanley Spencer, *Map Reading*, © Estate of Stanley Spencer 1996. All rights reserved DACS. Photograph Courtesy of the National Trust Photographic Library

> Wassily Kandinsky, *Birds*, © ADAGP, Paris and DACS, London 1996. Photograph Philippe Migeat © Centre Georges Pompidou

Hendrick Avercamp, *A Winter Scene with Skaters near a Castle*, Reproduced by courtesy of the Trustees, The National Gallery, London

Salvador Dali, La Table Solaire, © Demart Pro Arte BV/DACS 1996

Wayne Thiebaud © *Down Eighteenth Street (Corner Apartments)*, Photography by Ricardo Blanc

Indian, *The Siege of Ranthambore* from *The Akbarnama*, Courtesy of the Board of Trustees of the Victoria and Albert Museum

Roger de la Fresnaye, *The Conquest of the Air*, Photograph © The Museum of Modern Art, New York

Richard Eurich © Gay Lane

First published in Great Britain by HarperCollins Publishers Ltd in 1996 ISBN: 0 00 198181 1 (HB) 10 9 8 7 6 5 4 3 2 1 ISBN: 0 00 664580 1 (PB) 10 9 8 7 6 5 4 3 2 1 Compilation and text © Lucy Micklethwait 1996 All rights reserved. No part of this publication may be reproduced, stored in a retrieval system, or transmitted in any form or by any means, electronic, mechanical, photocopying, recording or otherwise, without the prior permission of HarperCollins Publishers Ltd, 77-85 Fulham Palace Road, Hammersmith, London W6 8JB. A CIP catalogue record for this title is available from the British Library. The author asserts the moral right to be identified as the author of the work. Printed in Hong Kong

TOPATOS NOR ROMAN